Woke to Birds

I.

best way

the best way to love a place like this is to remember we all /
leave someday /

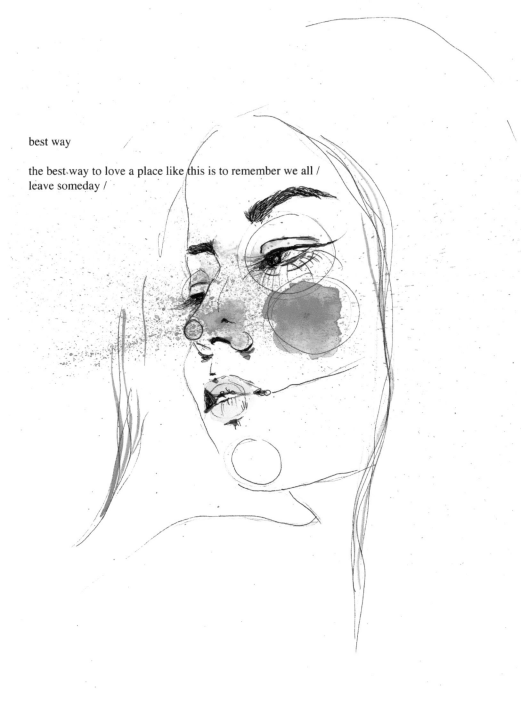

ghosts and the moon

he's backing the car out of a parking spot downtown and i ask him if he believes
in ghosts / he says no right away without / looking at me / that's how little the
question shocks him / i ask why and / he shrugs still without / looking at
me and says he outgrew the idea / he accepts that ghosts don't exist /
it sounds like this was something he had to come to terms with /
we're on the road now / moving through downtown and
heading home / it's dark and the sidewalks are busy
with people going to and from concerts and shows
and dinners and bars / i watch the people and i
want to say / i do believe in ghosts but / we
start talking about something else so / i
don't bring it up again / but right before
we turn onto our street we notice the
moon is red / he says some things
can't be explained and / i know
he's not just talking about
the moon /

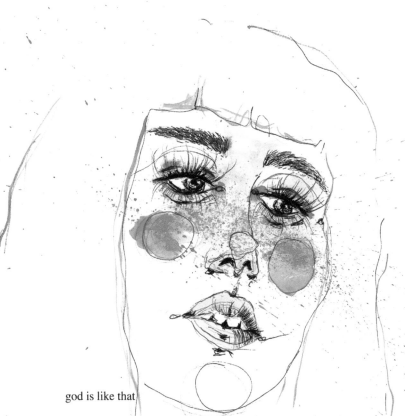

god is like that

yesterday i believed the most in god and / today the whole idea makes me / nervous
somehow like / an unexpected noise in the alley when / i take out the trash late at
night / i'm not saying god is like that but / the idea is untouchable sometimes and
that makes god untouchable and / faith untouchable and / hope untouchable so /
maybe tomorrow i'll believe again or / maybe not but / god is like that /

rises with wings

a young woman stands in the front yard of a / small yellow house and / blows kisses
towards the large window next to / the wooden door and / behind the window
there's a boy / no more than two years old with / his face pressed flat and
solemn against the glass the woman / keeps with her kisses and smiles
and / when the boy blows a kiss back she / laughs the kind of sound
that starts deep and then / rises with wings of momentary /
happiness before / she gets in her car and / drives away /

nervous

i blush in unexpected situations like / when a stranger says hi when
i'm out walking the dog / i know the formula: say hi back / smile /
wave / nod / give something of myself away / but it's like in
school when you study hard for a test and you memorize
the whole damn textbook but / you're still nervous
all the same /

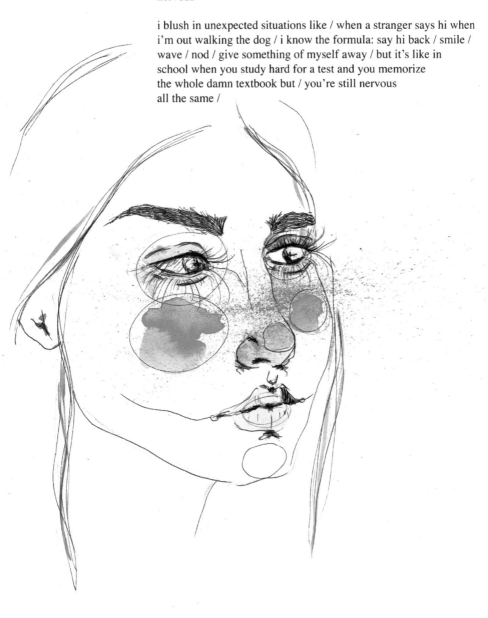

a home it will miss

we are not to be divided but / how can my soul depend on something so mechanical
as the body how can / the spiritual come from hands that move across the keyboard
in a routine of / muscle memory and brain signals see / the soul thinks the body is
laughable i can feel / the tension between the two the soul feels / superior to the
body even as the body bends down / to touch the dirt from where it came and
where it will return at least / the body has a known home at least / the body
does not worry about surviving death the body / knows its own limitations
but / the soul has so much to question and will never truly rest until / the
day of separation comes and then / the soul will see the body not as a
machine but as a home it will miss /

ritual

his neighbors ask him why he doesn't just buy a damn radio / that's not the point /
it's all part of the routine / leaving the house / smacking the pack of cigarettes on
his palm as he walks to the car / starting the engine and tuning the radio to
baseball / listening to the game while he burns 1 / 2 / 3 marlboro reds /
no one around to share with / just as well / his wife hated the smell
so / there he was in the car / and the neighbors say why not the
porch but / that just doesn't work in the wintertime and there's
no use changing one part of the routine / consistency is key /
but now he's alone and could smoke wherever he damned
well pleased the neighbors say / as if this is some kind of
consolation for having his whole world ripped away /
this ritual is a part of him now / his life wouldn't
make any sense without it / kind of like how it
doesn't make any sense without her but he
keeps waking up just the same /

my biggest fear

as a child my biggest fear was death and / i could not sleep in my own bed for many
years because / the darkness around me was the same / emptiness i could not
face / my mother read to me from the bible / 2 corinthians 5 / we will shed
our earthly bodies like clothing and / put on new bodies in heaven we will
not be unclothed like / the spirits / my father did not read from the bible
but / he told me stories from his catholic upbringing and / there was a
night when he talked of biblical authors / i was inconsolable after
learning god did not write the book himself how could / men
who have never died tell us of what's to / come as a child i
believed out of / fear and today i question belief from
the same fear /

split between the moment and everything else

you hear yourself walking on the leaves / you hear the plane overhead and /
the traffic of the arterial road nearby you / hear the whispering of your
consciousness which / is always far away you / are alone but not /
the streetlights come on one by one / staggered a few seconds in /
a way that seems natural and / inevitable / sameness and unity
make no sense when even inside our bodies we / are split bet-
ween the moment and everything else / how is it that our
imaginations are so powerful and yet / so constantly
wrong / this is nothing new / our mind's ability to
fantasize the worst or the best when / really
we'll get some middle ground / some
indifferent mixture of both /

rain he cannot see

when he leaves for work i am / still not finished saying goodbye to everything i love
about him i keep / waving from the window long after / he can see me just in case
he can feel it / somehow and the way my sleeves rustle is / the saddest sound in
the world for / most of the day he is at work / we live near a high school and it
is never quiet i / watch from the window to see what everyone's life is like /
the tree in our front yard is 100 years old and seems to listen when / i
whisper about my only problem of alone-ness / all day the rain and
there is so much life all over the place the lawn / is terribly green /
i stay inside pick up a paperback and / have some coffee /
all afternoon i think of him at work in / the windowless
building listening to the rain he / cannot see /
something important does not happen and
i wait for his headlights long into /
the evening /

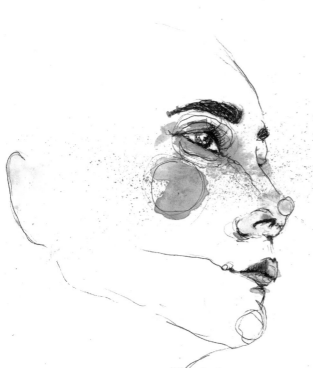

million deaths

carl sandburg says we each have a million deaths to die and / we
should be given a new name each time we / die into a new
world see / dying is the same as birth because / they
both take us to a new and different place so / why
be afraid / i ask this because
i am afraid /

for marie howe

the poet is explaining from her podium what a video store was
to a young student in the front row of the auditorium / she
says they were little stores / smaller than this room / with
rows and rows of VHS tapes that people spent hours
combing through / the tapes could be rented for
a day or two before they had to be returned and
it was important to rewind the tapes before
returning them / the student says so it's
like netflix in boxes / the poet combs
through her hair with her hand and
says sure / it's clear she's grieving
something and it's also clear
the student is working at
the idea of a video store
in his head and wanting
to walk into one now /
to browse the shelves
and touch the tapes /
to be in a place that
existed once but
not now /

before / it falls

there are people who say we are living in paradise right now / i see the way green
growth splits concrete and / how trees are tallest around cemeteries but / what
about the stars and / their promise of a distant and different place / do our
names even matter in the sky or / are we gods only here until / we're not /
this earth is the center of everything but / the center is always off-kilter
like / a spinning top wobbling before / it falls /

II.

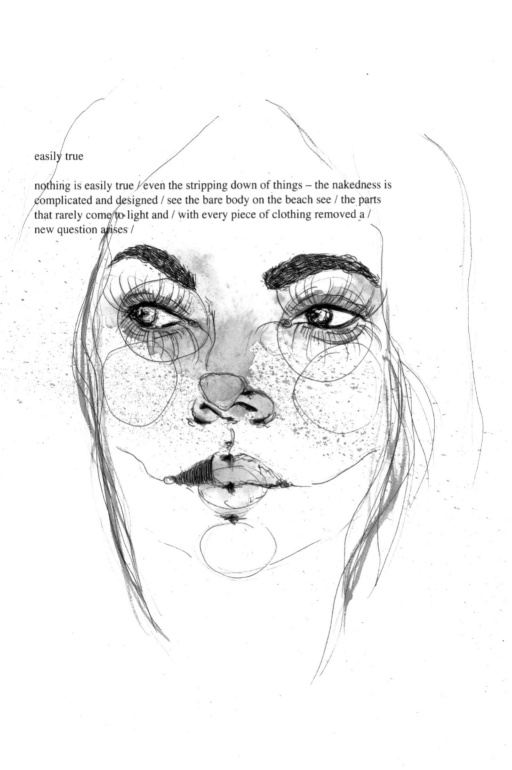

easily true

nothing is easily true / even the stripping down of things – the nakedness is
complicated and designed / see the bare body on the beach see / the parts
that rarely come to light and / with every piece of clothing removed a /
new question arises /

light-hearted and heavy-hearted

the ice cream truck / edit: pastel spray-painted van / its knowable melody
close by / sirens somewhere far off but still / the two existing in the same
moment / light-hearted and heavy-hearted just like me and you / some
days were made for breaking everything and starting over / more
sirens / i pray by lifting my hands and thinking of nothing / i
pray by singing your name over and over / the gas station
attendant from nepal told my husband everything is a
moment / there are moments of sadness / moments
of happiness / we can't become too sad or too
happy because both will pass / all we are
left with is our center / the ice cream
truck melody and the sirens fade /
i cover my ears with my palms
to hear the beating of my
heart inside my head /
funny how foreign
it sounds / how
unlike anything
else / how
small /

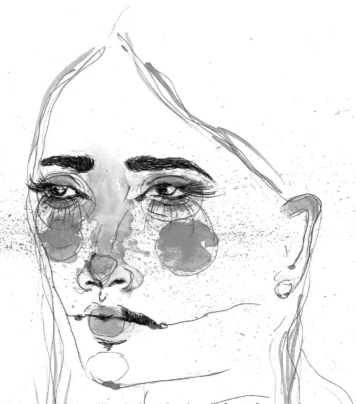

madness

some days i am afraid of small things like playing / the piano in front of anyone /
other days i am afraid of large things like death or / the silence of god / i do not
worry about small things and large things at / the same time because that
would be something like / madness /

npr interview with gary snyder

gary snyder says the work of poetry has to do with the "eternity of the present" /
snyder is 88 years old and lives in san francisco / long ago it was necessary
for him to ask / why are we here / and now he's stopped asking that
question / it's not a real question / he says / we're here because
we're here / being alive is wonderful and / he's ready to die
whenever that happens /

what if what if

if you're still wondering about god then you're not an atheist he says this /
definitively / his wife was not a religious person before she met him / she
took the conversion very seriously he says and became / a better catholic
than he's ever been or ever will be / his words / they grew up in the 20s
and 30s and i thought everyone believed / in god back then no / no he
says it was a lot like today some people / some families could care
less about / religion if this all turns out to be hocus pocus he says
but / doesn't finish the sentence so / we grow quiet a while and
stare out at the snow thinking / what if what if /

control

the mind wakes earlier than the body and / is left to study the dawn light on the walls and / wonder at the sound of a garbage truck in the alley hauling / guilt away in its mouth always / undone / the body stirs and the mind is careful / not to frighten it with responsibility but / thinks instead of food and / sunlight and clouds opening like / a blouse / the kinds of things the body likes and / the body rises from the bed / softly tortured into movement and / the mind gives it a few moments of / only awareness before taking control /

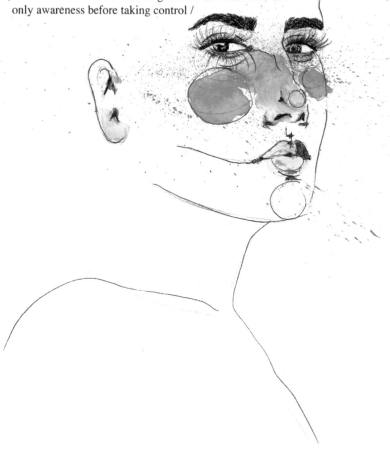

frank o'hara

confidence must be tempered with caution because / it's dangerous to believe
anything is possible we / would get hurt more than we hurt now if / we
never stopped to consider the many sharp objects guarding / our
dreams / frank o'hara wrote each time his heart breaks he feels /
more adventurous but / i don't believe him /

woke to birds

i woke to birds my eyes / were open and i could still hear them but / this is january
and the birds / left our city months ago so / i ask you what's more real / birds or
my thought of birds and you / would of course say birds because / my thoughts
are not your thoughts but / to me i cannot choose because / the boundary
between my mind and the world makes / less and less sense the more /
i pay attention /

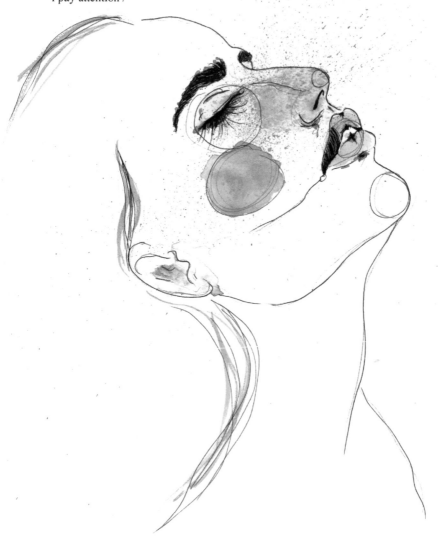

isolationism is a lie and so is the body

the body is immediate and demanding and seems / enclosed so / isolation is an easy
conclusion but / think of the breath that floods in and out and / is of us and outside
of us or / the way we take on and release water through / our skin this / tells us
how our bodies are not caged but / open all the time to the living things /
around us and / the language we use to describe this connectivity like /
collective and communal falls / short of how transcendent and
comforting it is to know / we are not alone /

pennies

she's older and becoming more and more like herself she / picks pennies off the
ground but only if / they're heads-up (for luck) if / they're tails-up she flips
them over with her shoe so / the next person can have the luck because /
she believes in good things happening / to everyone / she also picks
wild violets from other peoples' lawns and / when they smell of
nothing she is surprised but / she carries them in her hand for
blocks and blocks anyway /

for certain

for certain i know i exist and i know / you exist because i don't know myself well
enough to create / someone so right for me someone / or something else
created you maybe / you created yourself the same way you write
songs by / trying different chords together until / the melody
becomes clear maybe / you tried on different traits until /
the self became clear /

down-swinging

down-swinging you say and i think of / the playground the way i would rise from /
the rubber seat a few inches when / the swing met the sky and / how my stomach
would lurch as gravity or momentum or some / other undeniable force like my
own fear would pull / me back to earth what's pulling at you now / sweet
one i'll stand behind you and push so / you never stay down for long
before / rising again /

a thought comes

a thought comes and i turn it / inside out to see what it's made of and / by handling it like an object rather than / a truth i find / it has no power /

III.

stop

you can stop / running / your future has already
unfurled beyond you and / there are so many
places where / you will never exist /

the widow's black jacket

we all remember different dates for her death but / at least we agree on december /
the ground froze early that year with / a snap of single digit weather and / at her
burial we wore our thick wool coats over / dark dresses and suits / no telling if
there was snow on the ground but / its whiteness would make the widow's
black jacket even / more tragic and / misplaced /

grieve right away for me

people die trying to tell what it was like to be them and / to survive for ten or
twenty or fifty years is to remember / we're in the car and / something
is very funny between us so / we're laughing fully and / right in
the middle of this moment i think / i'll never remember this /
what we said or what it felt like to laugh together so / freely
and / i start to grieve right away for me and / for you /

collective consciousness

he's a man of routine but not of tradition / in the 1920s and 30s his family lit their
christmas tree with / candles that clipped onto the branches / the candles
were only as big around as pencils and / would burn quickly so / they
kept them lit for 10 or 15 minutes / at a time / here i am close to
a century later feeling / nostalgic for a time i've never / lived and
for a practice that sounds / dangerous and inconvenient / he
doesn't put a tree up anymore and / hasn't for years so /
when i ask him about the trees of his childhood he /
shrugs and tells me the facts but / without any
of the wistfulness that rises / up in me / for
memories that aren't / mine /

consciousness is a pond

who said this / my consciousness is a pond / still and deep but / my brain is a child
on the shoreline who keeps / throwing small rocks into / the water / rocks settle
at the pit of me / i become more shallow by / day's end /

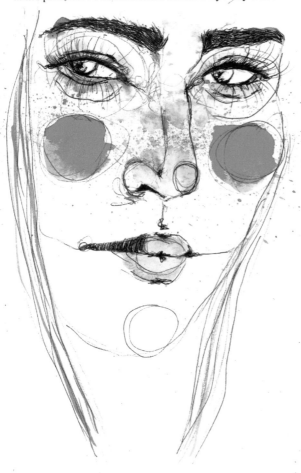

pale pollen

the pollen on the street is so pale it seems to glow in the dark / i try to understand
its pattern as i wait for his headlights / different from all the other
headlights on the block / to shine through me / wind chimes
somewhere and the skittering of leaves blown across
the sidewalk / how much i am a part of that i
don't understand / i haven't understood
prayer in a long time but / there
is a connectivity here / i
wonder what gets
left out / if
anything /

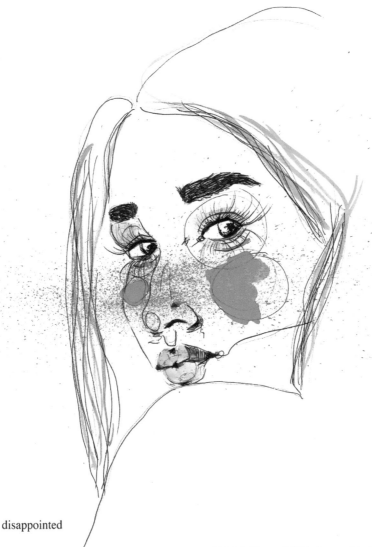

disappointed

he asked if i still say my prayers at night and / i felt like a child being scolded i said /
no he said / no good you should i asked / what does it do for you which / now
seems like the wrong question but / he said something special beyond
explanation and then / the phone rang and i couldn't ask him / any-
thing else but / days later reading sexton i think / of him again
and i / try out a prayer for anne because / she's already lost
and / i can't be / disappointed /

chronic alcoholic

if one july evening you find yourself crossing the street in your pajama pants and
socks to crash a neighboring drum circle / carrying a bottle of cough syrup
because you ran out of old crow / you're probably a chronic alcoholic /
now you're fiddling with the latch on the neighbor's gate for some-
thing close to five minutes because your eyes won't focus and /
maybe you're only sixty-two but christ you / look more like
eighty / you're probably a chronic alcoholic / you're lucky
the neighbor lets you in / you're lucky this drum circle
is all about spirituality and finding your own rhythm
because / you're spinning in circles that have
nothing to do with the beat of the congas /
how many times have you been to rehab /
how many times have you wished for a
different brain / one that works with-
out the slosh of whiskey in the morn-
ing / your wife's red car comes
down the road and everyone
smells a fight / she parks
and walks into the
house to find you
elsewhere / but
you are no-
where /

hemingway

hemingway says all stories end in death but this seems to lack / imagination / even
so hemingway was close to death in the first world war when / mortar fragments
and machine gun rounds ripped through him he felt / his soul being pulled
from his body like a handkerchief and if / the soul is being pulled it must
have a place to go instead which seems / less like an ending and more
like a transition / hemingway shot himself in ketchum idaho which /
is eight hours and forty seven minutes from my house he was / six
feet tall and weighed 200 pounds his fourth wife who / lived with
him at the time says the death was an accident but / she was
asleep when the shot was fired and so / will never truly
know the sheriff of ketchum said / he could not declare
the shooting accidental and he could not declare it
suicide because there was no witness / no note /
just the reality of a soul left / for elsewhere /

parents

how can we still be surprised by / what our parents have done when / we know
them only in one way / how complicated it must be for the parents to exist /
outside of parenthood to have / a history before us and a future / without
us and even / moments in the present when everything drops away /
children included and / all that's left of a parent's life is whatever
they carry around inside of them /

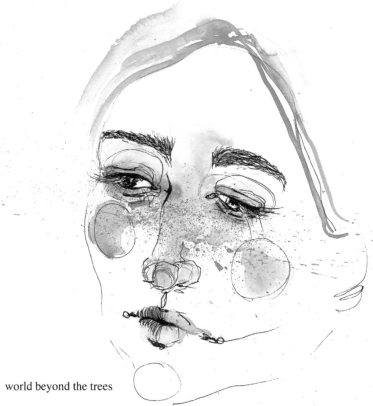

world beyond the trees

the sun seems most powerful but day by day it follows the path
laid out for it like a dog circling the tree to which it's chained /
the snap of an old flag in the wind is no more and no less
important than the strange language of small birds /
the world beyond the trees is falling apart which /
changes everything / if i stayed here could i
become myself again / there are no hours /
only times of more light and less light /
the black lake at dusk / the sun
almost gold in its dying /

we sit on

the dog sits with me out front and we watch the day
turn dark / somewhere / a scream / we look at
each other and try to decide if anything
should be taken seriously / the dog
rests her head on the porch and
closes her eyes / i do the
same / night comes
and we sit on /

cutting out

are you there / i can't hear you / it sounds like you're underwater / yes /
honey / can you hear me / this phone cuts out sometimes / maybe i'll
call you back / maybe i'll hang up and take a walk / then we'll try
this again / we'll suffer through the silence and come out
the other side with so much to say about the mess we
made / people have done this before but not us /
what should we believe in next / are you
there / honey / i'm going to
hang up now /

sad things

i don't remember the last time i cried even though / the same amount of sad things
keep happening /

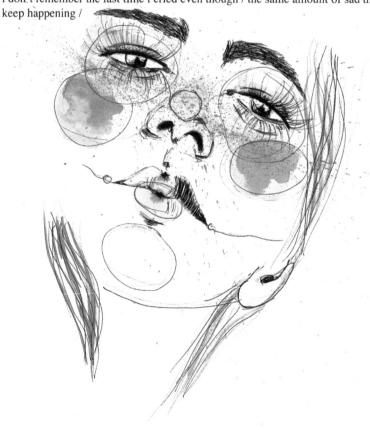

IV.

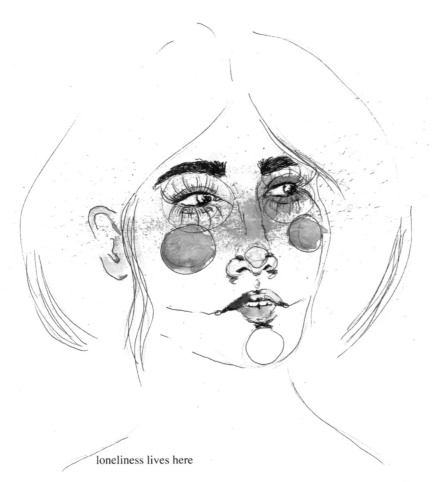

loneliness lives here

the winter river and the river in june / split in the same way we all are / the two of
you / the part in love with what is and the part in love with what was /
not the same / loneliness lives here / in the disconnect /

what does that tell you

there's no way to explain the feeling of waking up to another day / in my body in my
brain and without any evidence of / the soul i know it's there but / convincing
others is the problem it's like / i have an invisible friend from childhood who
never went home when it was time for dinner rather / the friend just hung
around like some forgotten kid on the curbside of a closed school and /
waited for a parent who never showed / this invisible friend this soul
is part of everything that means anything but / when i try to look
straight at it i see only me what does / that tell you /

the soul

i ask him if he believes / in the soul and he says / there's no need not to believe /
this makes more sense to me than / anything and / i nod knowing. / there's
nothing else to add /

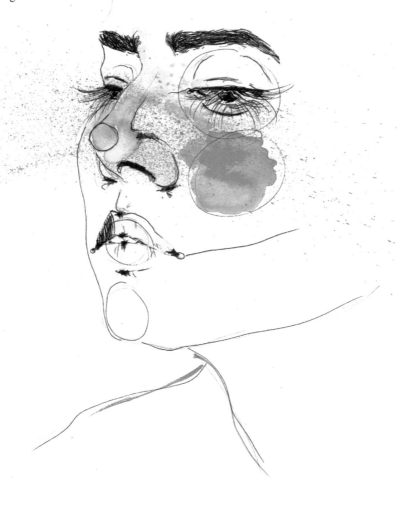

christmastime

my grandfather was born in 1925 in a town / of a thousand people to immigrant
parents they / spoke austrian at home but / my grandfather and his brothers
they / spoke english and / walked every day to / the catholic school across
town / every one of them had jobs by the time they / were five or six /
delivering papers or / picking up nails from a jobsite / christmastime
they would save some / earnings here and there to buy / their
mother a pair of slippers from / the sears roebuck and
company catalogue / freight came on trains back then
and / the slippers delivered practically / overnight /
christmas eve mass was held at midnight in /
the white church with the copper spire /
after they would eat a meal at 1 or 2
and / go to bed full and warm
with / the fire down
to the coals /

the walls

it's waking up and spending / the morning reading next to a window that faces / the street and tasting / the familiarity of everything i don't mean / to generalize but / everything has happened to each of us because / we are / one i don't need to / clarify but / we build our own walls around our own selves and / those walls are sad and isolating so / the more aware and familiar we become the more / we see the futility of / the walls we can't / keep out everything because / we are everything /

a while longer

he wants another dog / his died over a year ago / went off by herself and never
came home / one of the kids found her down by the creek and drug the
body back / every time i see a dog on the television i smile he says /
doesn't matter what kind of dog or what the dog is doing he says /
he's close to 93 now but he's healthy i tell him / why not get
another dog i tell him / he gets his exercise and eats right
i tell him / he doesn't drink doesn't smoke i tell him /
maybe i should start he says / i talk about something
else / maybe i should start he says again mostly to
himself / loneliness is the only word for it / lost
his wife years ago / and now the dog he can't
bear to bond with anything or anyone else /
loneliness is all that's left / i spot a bird's
nest by the front door when i leave and
i tell him about it / his eyes light up
and i know it will be enough to
keep him here for a while
longer /

tidying up

the strange ceremony of tidying up before bedtime / gathering
papers and building piles and shutting drawers to return
to a precise order that means nothing / the house is
only a passageway from the world beyond the
front door to the world beyond the back
door / i understand control does not
exist but i clean up anyway /

touch but can't

we wake up to the silence and we want it to / mean something we / wander from
room to room and pick up empty cups we / forgot about / we have some coffee
and / ask things of each other for the day and / who would we be without our
problems and / who would we be without the stories of / far away people /
we leave the house and become far away / people ourselves and / we think
of each other and send our / warm thoughts to the sky and hope they /
will fall as rain the way we / want to touch but can't /

materialism

consciousness is a good friend to me but
it is not me / kind of like a reflection in
something not meant
to be a mirror /

something sweeter

we sit in our separate rooms scrolling through the news on our phones / worrying
about *every* single person in the *entire* world and / therefore worrying about no
one at all / we close the windows and / feel ashamed of the quiet / we turn off
everything that can be turned off and we / change into ourselves without
distraction / we sort what we remember we / make piles in our minds
of love / the piles smell like laundry like / human sweat and
something sweeter /

alive somewhere else

some days i think maybe we made a mistake burying you maybe / you weren't dead
after all and / the whole ceremony was wrong / i want to dig you up because
maybe you're scared of the dark down there and maybe / the casket lid is
too heavy for you to lift / it doesn't matter that i'm an adult / too old
to be having these thoughts of resurrection / today i stare at the soil
above your grave / i bend down to touch its darkness and / i see
slim strands of grass breaking through the earth and somehow /
this tells me you're dead here but alive somewhere else /

try to name

there are people i miss who i don't really remember maybe / it's my energy missing
their energy / i'm not embarrassed to think this / materialism makes no sense to
me the whole world disappears all / the time and / i'm left with whatever is
inside my head nothing / decomposes and it all means / so intensely /
forgive me for believing in what i can't and / won't try to name /

Acknowledgments

"disappointed," "consciousness is a pond," and "collective consciousness" first published in *Rabid Oak Journal*. February 2019.

"ghosts and the moon," "million deaths," "alive somewhere else," "god is like that," and "before it falls" first published in *Anti-Heroin Chic Journal*. October 2018.

"a while longer" and "light-hearted and heavy-hearted" first published in *SUSAN / The Journal*. July 2018.

"rain he cannot see" first published in *Lit-Tapes*. May 2018.

CPSIA information can be obtained
at www.ICGtesting.com
Printed in the USA
BVHW022026161019
561250BV00003B/2/P